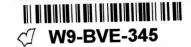
Color...What Is It?

According to the theory of color, no object contains color within itself. Color is a sensation produced when light rays are received by the retina of the eye and interpreted by the brain. Light is projected in long and short waves; when it strikes an object, the object absorbs some of the light rays and reflects others, thus, radiating color to the eye.

Paint pigments are solid substances. In and of themselves, they have no color, but when light rays strike them, some rays are reflected back to the eye and absorbed by the brain through the sense of sight, and the sensation of color is experienced. Each pigment takes on a different color depending on its ability to absorb or reflect specific light rays. This ability is affected by several things, including the molecular structure of the object and the texture of the object (e.g., smooth and shiny or rough and dull). Some objects absorb light rays and reflect very little light back to the eye; these objects are seen as dark colors. Objects that reflect more light rays are seen as lighter colors and give off more brilliance and intensity of highlight.

Light is the source of all color—but what is light? Scientists have discovered that light is electromagnetic energy that comes to us in waves of different lengths—all traveling at approximately the same speed. Because of the variations in wave length, light can be visible or invisible. Visible light gives us the color spectrum.

When painting, we must consider how light will affect the painting. For example, light is different at different times of day—early morning, afternoon, or evening. Light also differs during different seasons; winter light is cooler and the summer light is warmer.

Sir Isaac Newton discovered that when light passes through a prism it breaks up into seven colors: red, orange, yellow, green, blue, indigo, and violet (a rainbow). While striving to prove his theory, Newton projected the seven colors through a second prism. The result was white light—a reproduction of sunlight!

Artist and scholar Albert A. Munsell created a color system in 1898 which organized the colors on a color wheel. The Munsell system breaks down the colors of the spectrum into three dimensions: hue, value, and chroma (intensity). The **hue** is the actual name of the color; **value** is the lightness or darkness; and **chroma** is the degree of purity or greyness. The color wheel is used to present color in simple chart form so the colors can be visualized and compared.

The three **primary** colors are yellow, red, and blue. When yellow and blue are mixed, green is obtained; when yellow and red are mixed, orange is obtained; and when red and blue are mixed, purple is obtained. Thus, green, orange and purple are the **secondary** colors. Mixing a primary color and a secondary color produces a **tertiary** color. For example, red and purple make red-purple, yellow and green make yellow-green, and so on around the wheel. Yellow is the lightest color in value on the wheel, and purple is the darkest. Any two colors directly across from each other on the wheel are known as "complements" (e.g., red and green and yellow and purple).

The color wheel contains twelve pure colors. Now we must consider three more terms: tint, shade, and tone. When white is added to any color, a **tint** of that color is created. For example, pink is a tint of red. When black is added to a color, a **shade** is obtained. If black and white are mixed into a neutral grey and then added to a color, a **tone** of that color is obtained.

The painting below is a good example of light-controlled color. The red cardinal is nature's perfect complement to the green leaves. I hope you will find this information helpful in your painting.

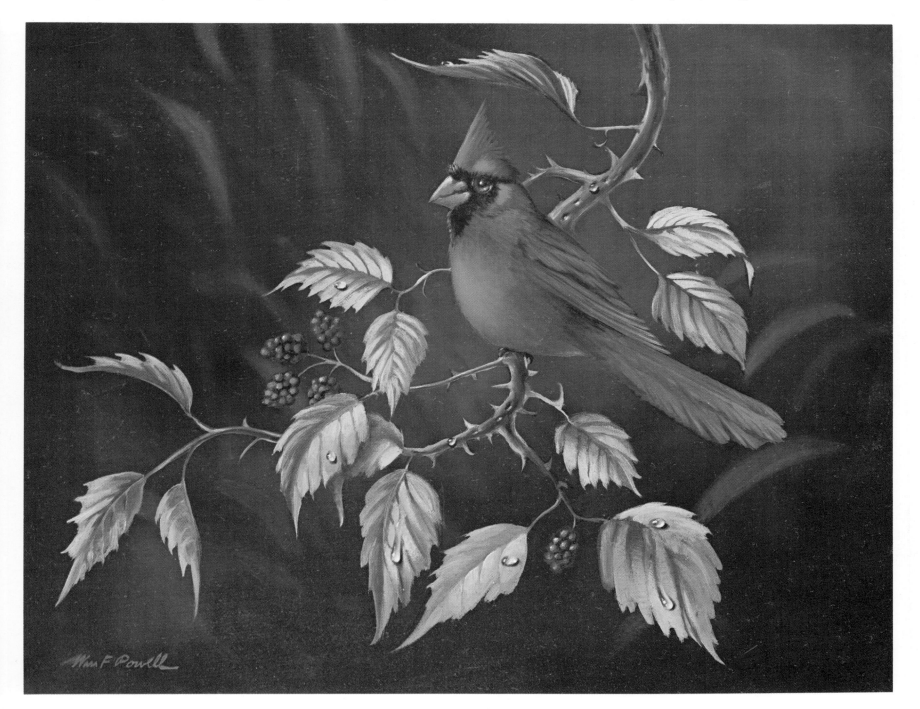

The Color Wheel...Making it Work for You

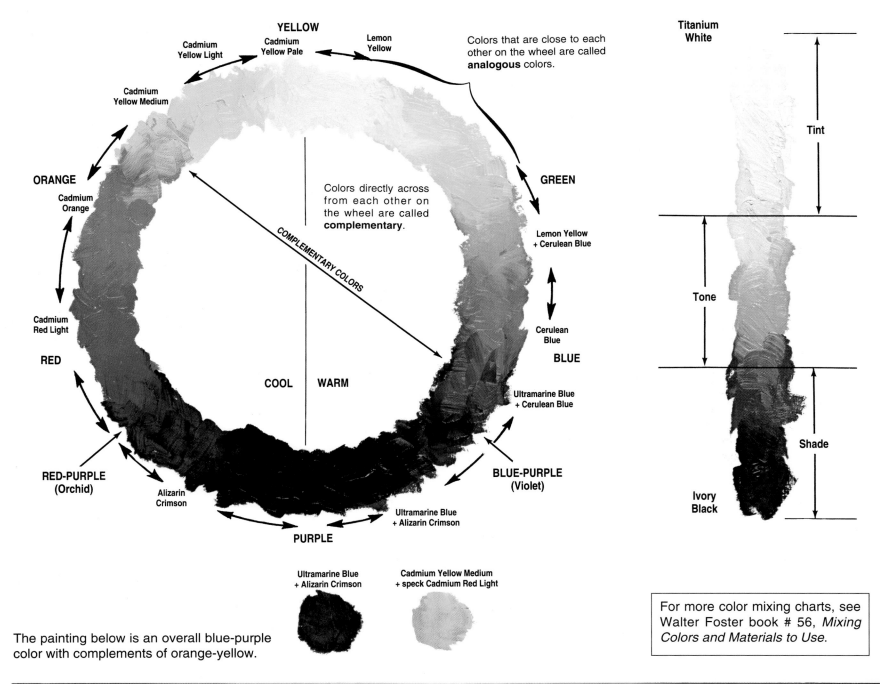

YELLOW

Cadmium Yellow Pale

Cadmium Yellow Light

Lemon Yellow

Cadmium Yellow Medium

Colors that are close to each other on the wheel are called **analogous** colors.

ORANGE

Cadmium Orange

GREEN

Colors directly across from each other on the wheel are called **complementary**.

COMPLEMENTARY COLORS

Lemon Yellow + Cerulean Blue

Cadmium Red Light

Cerulean Blue

RED

COOL WARM

BLUE

Ultramarine Blue + Cerulean Blue

RED-PURPLE (Orchid)

Alizarin Crimson

BLUE-PURPLE (Violet)

Ultramarine Blue + Alizarin Crimson

PURPLE

Ultramarine Blue + Alizarin Crimson

Cadmium Yellow Medium + speck Cadmium Red Light

Titanium White

Tint

Tone

Shade

Ivory Black

The painting below is an overall blue-purple color with complements of orange-yellow.

For more color mixing charts, see Walter Foster book # 56, *Mixing Colors and Materials to Use*.

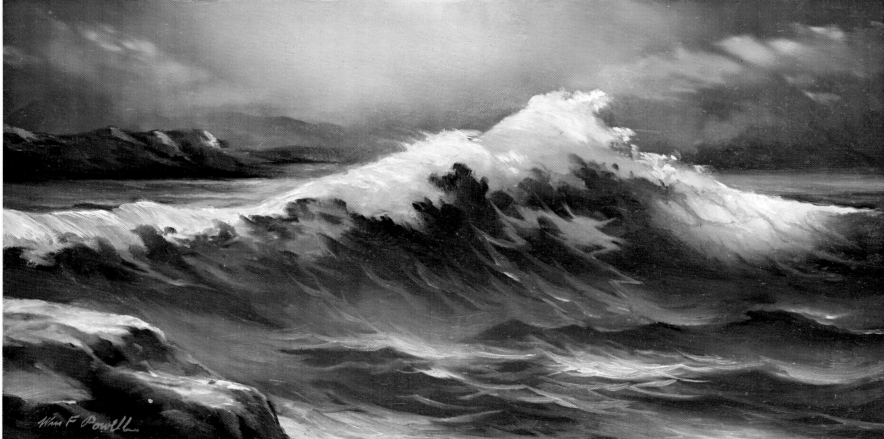

2

The Color Wheel as a Tool...

The color wheel arranges colors into harmonious groups. It is useful for selecting colors for a palette and selecting the proper colors to use as natural greying agents for other colors. Colors cannot be greyed by adding black or a colorless grey mixed from white and black (page 6).

Direct complements grey each other better than any other colors on the wheel (this is called "natural greying"). Greying a pure color makes it more harmonious for use with other colors. Shown below are a few direct complements and the neutrals that are created by mixing them.

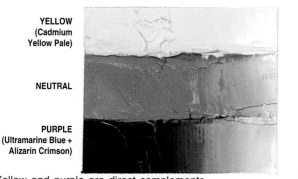

YELLOW
(Cadmium Yellow Pale)

NEUTRAL

PURPLE
(Ultramarine Blue + Alizarin Crimson)

Yellow and purple are direct complements. When mixed together, the result is a natural greying of color called a "neutral." + white

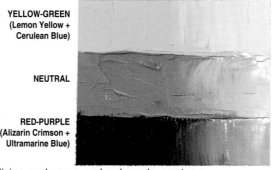

YELLOW-GREEN
(Lemon Yellow + Cerulean Blue)

NEUTRAL

RED-PURPLE
(Alizarin Crimson + Ultramarine Blue)

Mixing cool green and red-purple creates a slightly different grey. Notice how white affects the colors and their neutrals. + white

GREEN
(Lemon Yellow + Cerulean Blue)

NEUTRAL

RED
(Cadmium Red Lt.)

The natural greys of warm colors (reds) are warm also. Always use each color's direct opposite. + white

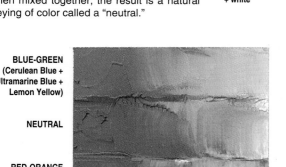

BLUE-GREEN
(Cerulean Blue + Ultramarine Blue + Lemon Yellow)

NEUTRAL

RED-ORANGE
(Cadmium Red Lt. + Cadmium Yellow Medium)

Adding red-orange to blue-green neutralizes the color to an "olive drab." To make it cooler, add more blue-green. + white

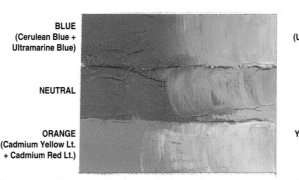

BLUE
(Cerulean Blue + Ultramarine Blue)

NEUTRAL

ORANGE
(Cadmium Yellow Lt. + Cadmium Red Lt.)

Orange and blue are direct complements, so they alter each other very nicely. For cooler grey, add more blue. + white

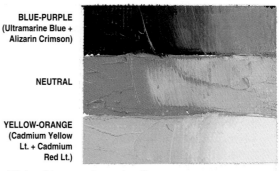

BLUE-PURPLE
(Ultramarine Blue + Alizarin Crimson)

NEUTRAL

YELLOW-ORANGE
(Cadmium Yellow Lt. + Cadmium Red Lt.)

Mixing blue-purple and yellow-orange can create some very dark, moody greys. Add more blue-purple to make the mixture darker. + white

Using Split Complements...

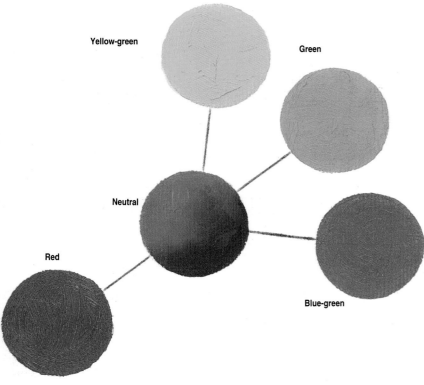

Yellow-green

Green

Neutral

Red

Blue-green

Select a color and find its direct complement. Then look at the next lighter color and next darker color of the direct complement; these two colors are the first color's **split complement**. Split complements allow for a much broader palette of colors; they also create a larger spectrum for greying colors naturally. Notice that red can be greyed with either yellow-green or blue-green. Each would produce a different grey, providing many more colors to work with. Move this diagram clockwise around the color wheel to see the tremendous variety of mixtures possible.

Color Harmony...
Using Analogous and Ruling Colors

Colors are also harmonious by being **analogous**. Analogous colors are close to one another on the color wheel. For example, yellow-orange, orange, and red-orange are analogous. Look at these three colors on the wheel. The color in the middle (orange) is the "ruling" color. This means that the other two colors contain orange, and orange can most easily alter them. Move around the wheel and select any three colors in a row. The color in the center of the three is always the ruling color. Study the different families of color on the wheel; try to decide which colors are analogous and which are not. For example, some of the yellows are very similar, yet others are very different.

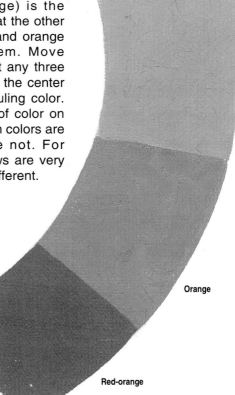

Yellow-orange

Orange

Red-orange

Painting with Greys...

The colors listed here are used for the paintings below. Respecting white as light, we can see the beautiful colors that are possible by intermixing them. Notice the subtle greys that occur when complementary colors meet. Colors in nature are filled with greys. The greens in different species of trees vary a great deal. They all contain at least a speck of color in the red range. This is the natural way to grey greens. Black is not a natural greying color; it is the absence of light and, therefore, only deepens the value. When colors are greyed correctly, any fresh color placed with them will sparkle. Try these quick exercises on your own, concentrating on that sparkle.

Since black is the absence of light, it is also the absence of color. When white is added to black a colorless grey is obtained.

Black can also be used to **shade** a color, creating a different visual color. For example, yellow shaded with black appears green, and red shaded with black appear purple. When black is used in this manner (as a pigment) it falls into the blue family because any blue mixed with yellow makes green and any blue mixed with red makes purple. (Note: burnt umber and ultramarine blue make a beautiful black.)

Color + White Pure Color

Burnt Umber

Alizarin Crimson

Cadmium Orange

Yellow Ochre

Cadmium Yellow Light

Ultramarine Blue

Prussian Blue

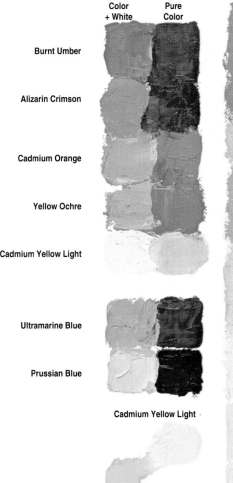

Cadmium Yellow Light

Prussian Blue

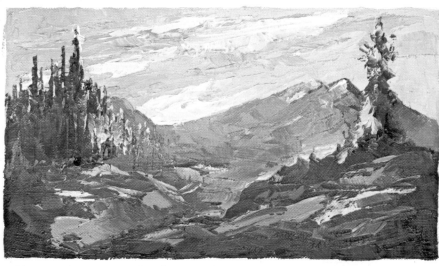

Pale blue and warm orange make a nice color transition.

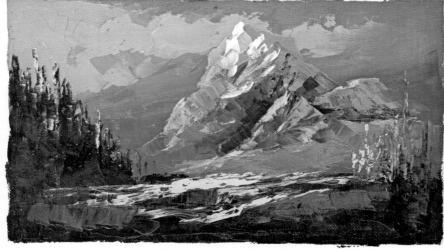

Notice the sparkle of the grass against the background greys.

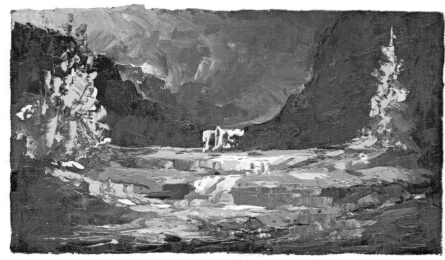

Here we have greyed yellows and greens against a warm foreground.

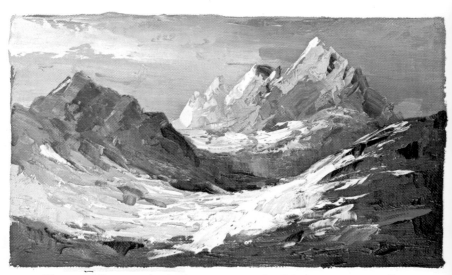

Blue and its complement, orange, make this scene come alive.

Color Moods...

Color affects mood; that is, most people react emotionally to color. For this reason, color is used in the psychology of sales; it is carefully considered when choosing the backgrounds and product presentations for print advertisements and television commercials. It is also considered carefully in interior design. For example, colors such as red and orange (and others that are seemingly warm) are not usually used in places such as hospital recovery rooms, but they are used in areas such as cafeterias where the public is supposed to move rapidly in and out without feeling hurried physically. Shown at the right are some examples of different color moods and the typical reactions to each.

When direct complements are used in their pure state (without being greyed), they are loud and uncomfortable to view.

Dark purples and blues can create a feeling of mystery and mysticism.

Pale blues and slight hints of greens are considered cool and pleasant.

Warm oranges and yellows are often associated with sunlight.

High Key...

A very light painting that contains a lot of white is known as a "high key" painting. Using color in this manner produces a work that is light and airy. In this type of painting, the value changes (see page 6) are very subtle. These three paintings are "thumbnail" oil sketches; they were painted the same size shown. This is the best way to work out color schemes for larger works.

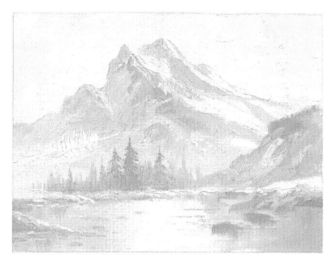

White + Zinc Yellow

White + Cerulean Blue

White + Cad. Red Lt.

Above colors + Alizarin Crimson

Middle Key...

Adding a value of grey (produced by mixing white and black) to the colors of a painting creates a "middle key" painting. When using this type of color scheme, one must carefully plan the color mixtures and be sure not to overuse the grey! Too much grey will mute the colors, making the painting drab. The idea is to use the grey to just slightly control the colors.

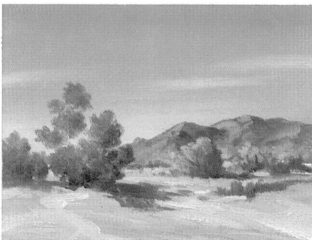

White + Ivory Black

White + Cobalt Blue

Add speck Alizarin Crimson

White + Burnt Umber + Aliz. Crimson

Mix all together

White + Cad. Yellow Medium

Blue + speck Yellow Ochre

White + Alizarin Crimson

Low Key...

Using dark colors and adding black to them creates a mood known as "low key" painting. The light from the moon plays on the water and the dark value of the blues and black emphasize its brightness. However, black must be used only to control the colors slightly or the entire painting could become dull. Try to make your mixtures appear lively in color.

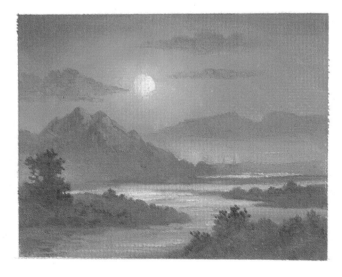

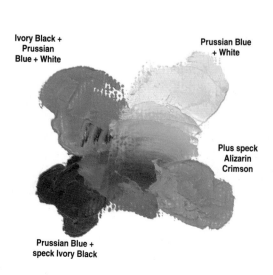

Ivory Black + Prussian Blue + White

Prussian Blue + White

Plus speck Alizarin Crimson

Prussian Blue + speck Ivory Black

5

Lightening and Darkening Colors...

Value
Scale

Reds

Blues

Value
Scale

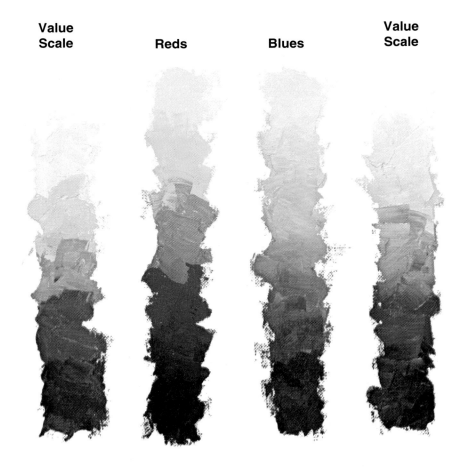

Like the value scale, the color wheel is both light and dark. White is lightest on the value scale, and yellow is lightest on the color wheel; black is darkest on the scale, and purple is darkest on the wheel.

When using white to lighten a color, also add a speck of the color above it on the wheel. For example, when adding white to cadmium red light, add just a speck of orange. This will keep your colors fresh and clean. The same rule applies when darkening a color. If you add black to a color, add a touch of the color below it on the wheel.

Purple is obtained by mixing red and blue. A red-purple is orchid; a blue-purple is violet. If white is added to any of these colors, lavender (pale purple) is produced. Adding white creates a **tint** of the color; adding grey creates a **tone**; and adding black creates a **shade**.

The examples to the left compare the colors of the wheel to the lights and darks of the value scale.

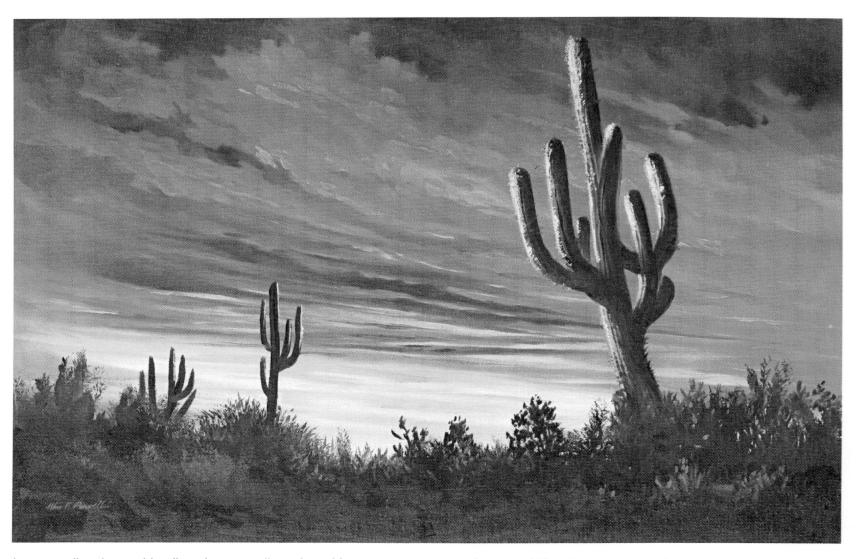

Lemon yellow is a cold yellow. Lemon yellow plus white creates a nice glow when placed against purples. Yellow and purple are directly across the wheel from each other, so they are **complements**. When these two complements are mixed together, a soft tannish grey is obtained. Try this exercise on your own, and don't be afraid to experiment with your mixtures!

Color Mixtures...Adding White or Black to Color

The colors on this page have either been lightened (tinted) with white or darkened (shaded) with black. Other (mostly analogous) colors were also added (as suggested on page 6) to keep the mixtures fresh. Notice the first three mixtures; the mix of white and burnt umber is rather dull and lifeless, but when other colors are added, it becomes livelier. Once a soft color has been obtained, you can use it as a base for other mixes. The color mixtures directly below were made with titanium white. The second set (at the bottom) was mixed using ivory black.

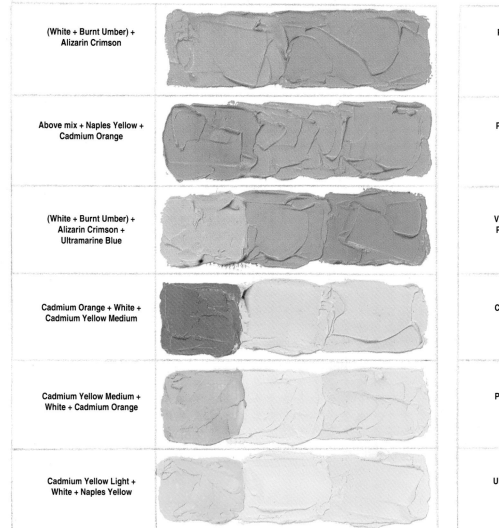

(White + Burnt Umber) + Alizarin Crimson	
Above mix + Naples Yellow + Cadmium Orange	
(White + Burnt Umber) + Alizarin Crimson + Ultramarine Blue	
Cadmium Orange + White + Cadmium Yellow Medium	
Cadmium Yellow Medium + White + Cadmium Orange	
Cadmium Yellow Light + White + Naples Yellow	

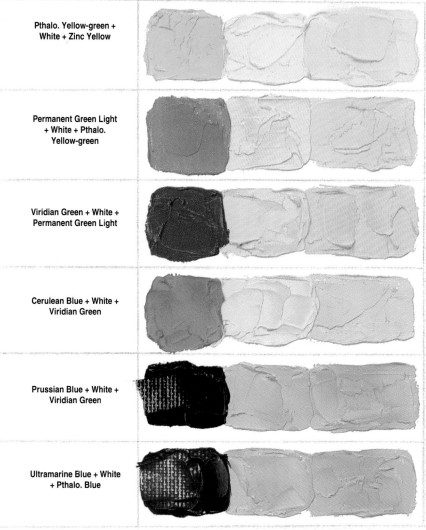

Pthalo. Yellow-green + White + Zinc Yellow	
Permanent Green Light + White + Pthalo. Yellow-green	
Viridian Green + White + Permanent Green Light	
Cerulean Blue + White + Viridian Green	
Prussian Blue + White + Viridian Green	
Ultramarine Blue + White + Pthalo. Blue	

Adding black to a color can make the color appear dull. To bring back its freshness, add a touch of the color below it on the wheel or any other color that appears darker. Experiment and create some mixtures of your own. Remember to take notes so you can repeat a successful mixture when you wish.

Cadmium Yellow Medium + Ivory Black + Cadmium Orange	
Yellow Ochre + Ivory Black + Cadmium Orange	
Cadmium Orange + Ivory Black + Cadmium Red Light	
Cadmium Red Light + Ivory Black + Alizarin Crimson	
Raw Sienna + Ivory Black + Burnt Sienna	

(White + Viridian Green) + Ivory Black + Cerulean Blue	
Cerulean Blue + Ivory Black + Ultramarine Blue	
Cerulean Blue + Ivory Black + Viridian Green	
Permanent Green Light + Ivory Black + Viridian Green	
Pthalo. Yellow-green + Ivory Black + Permanent Green Light	

Time of Day...

When planning a painting, one must consider time of day and the warmth and coolness of the light source because the color of light affects all objects in the painting. For example, if the light source is bluish, all objects touched by it will have a blue cast. A morning sky is crisp and cool, but it can contain some soft, warm clouds. To help control the time of day, use the following color suggestions; select the time you want to portray, and then put a touch of its color into every mixture used in your painting.

Early morning: Lemon Yellow
Mid morning: Cadmium Yellow Light
Midday: Cadmium Yellow Light/Cadmium Yellow Medium
Early afternoon: Cadmium Yellow Medium
Late afternoon: Cadmium Orange
Early evening: Cadmium Red Light/Alizarin Crimson
Evening: Blue-purple

Cerulean Blue + Ultramarine Blue Ultramarine Blue + Alizarin Crimson

Lemon Yellow Cadmium Yellow Lt. Cadmium Yellow Med. Cadmium Red Lt. + Alizarin Crimson

The three examples on this page show the same subject at different times of day.

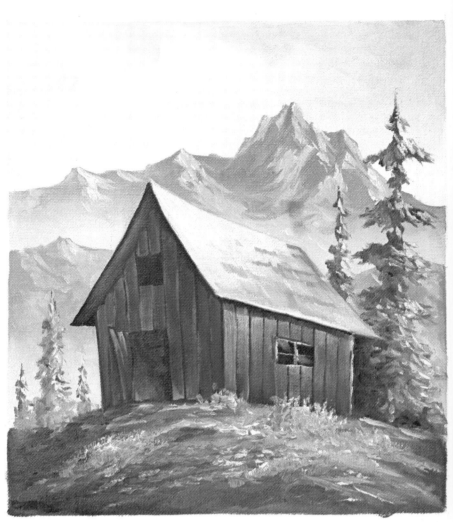

Early morning light provides a cool sky and cool highlights on trees and mountains. (The low angle of light also shows that it is morning.)

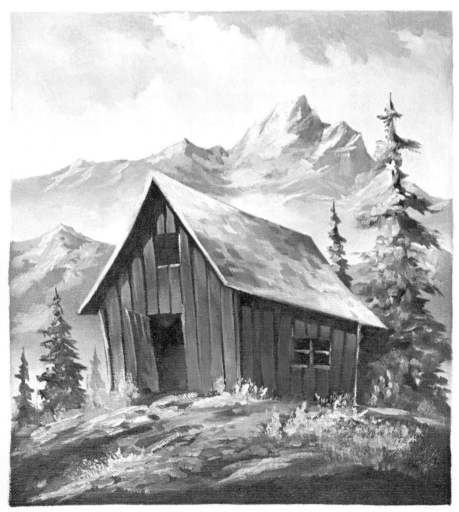

The sky and the mountains appear a bit warmer in the afternoon. The shadows moved from the left to the right as the sun moved across the sky.

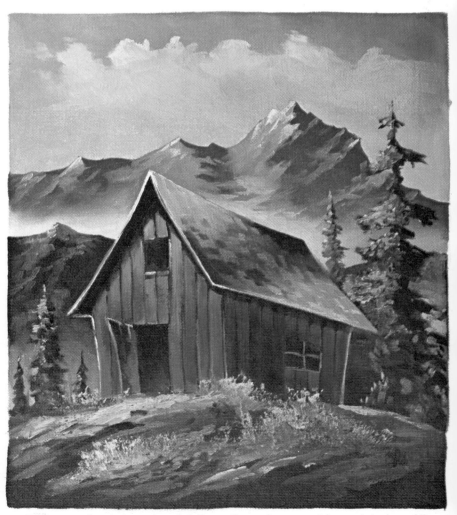

Early evening brings a quiet time; the colors must be quiet also. All areas of the painting should be deeper in tone. Soft mixtures and textures also enhance the mood.

Colors...from Sunrise to Sunset

Morning

Morning colors are softer and cooler than afternoon colors because in the morning the air is clearer and the earth is cooler, creating cleaner light. Although the light is soft, there are still a lot of color dramatics in the morning. (The paintings on this page are thumbnail oil sketches; they are shown actual size.)

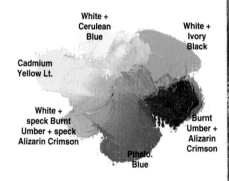

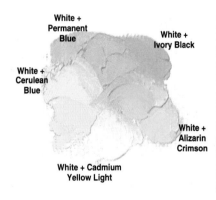

The great change in values between the shadowed foreground and the soft sky add to the drama of this sunrise.

Midday Light and Shadows

Light and shadows are more difficult at midday because of the position of the sun. Notice that there are no long shadows. Here, the vertical direction of the redwoods makes a perfect composition.

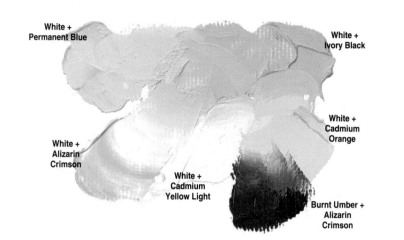

Afternoon Softness

There is sometimes a soft haze that settles in an afternoon scene, as shown here in this painting of the Yosemite valley. Use a mixture of titanium white and ivory black to subdue the colors (use the black very sparingly!).

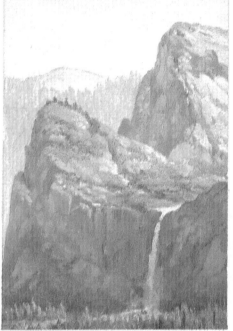

Setting Sun

A setting sun can be very soft, yet dramatic. This is especially true over a body of water because the moisture in the air affects the light rays. Here, the light source behind the dark clouds projects the rays into the sky causing an asterism effect. Note: sunsets do not have to be bright and heavy with oranges and reds; at times, they can be very delicate.

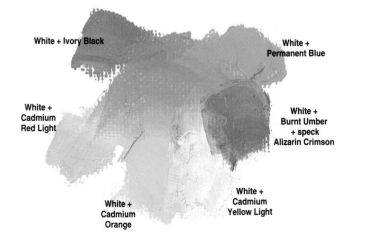

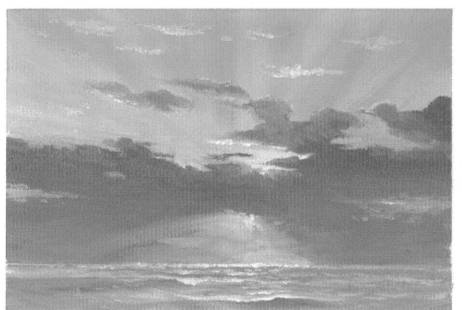

Study sunsets on different days. Notice the color difference between dry days and humid days. Try using a black of your own. A good one to start with is a 1:1 mix of burnt umber and permanent blue. You can make the mixture warmer by adding more umber or cooler by adding more blue.

Color Notes...

Always keep notes on your color mixes and brush combinations so you can "remember" them if you want to use them in the future. Notes also provide a record of your ideas or color impressions while on location.

First study your subject and select the colors that seem to fit. Then, using a knife and white, mix the values (lights and darks) for the main colors of the painting. (I call these mixtures **intentionals** because they are *intentionally* mixed to a specific value to work well when mixed into all the other mixes). Make a "smearing" of the intentionals (as shown) to see if the desired color mood is achieved; then label the colors (1, 2, 3, etc.).

During the painting process, the intentionals are manipulated and intermixed on the palette and canvas to produce an unending array of colors that I call **accidentals**. These colors are actually *planned* accidents, and they make up the majority of color mixtures in the painting.

The color swatches at top left are the intentionals; those at right center are accidentals. Use scrap paper, canvas pads, or any material you have handy for making these quick color sketches. The color sketch notes here are shown actual size.

Pencil in notations on your sketches, and then file them away for future use. These notes will develop into a "morgue" of color mixtures that you will refer to for the rest of your painting life. You may want to attach a snapshot of the finished painting to the notes to prevent future confusion as to which notes belong to which painting. Good luck!

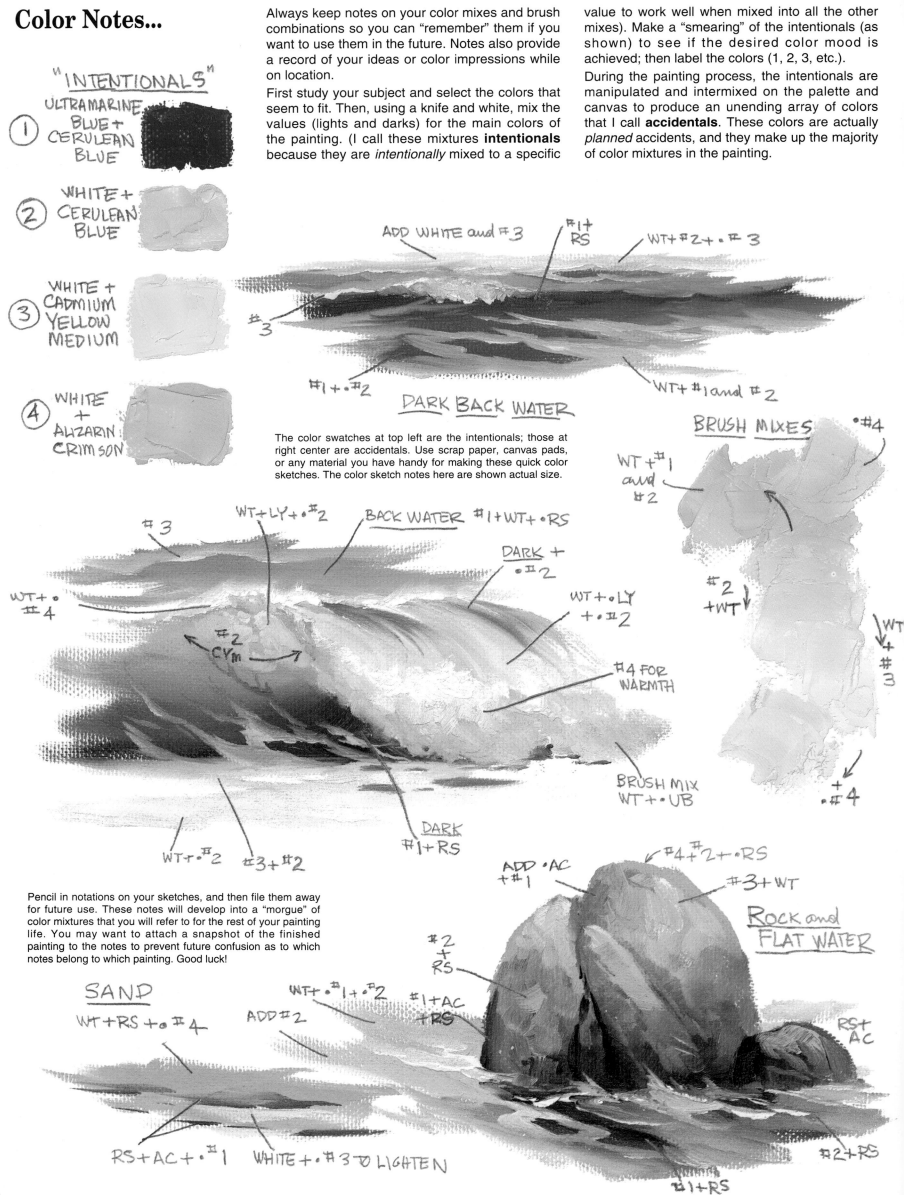

"INTENTIONALS"

① ULTRAMARINE BLUE + CERULEAN BLUE

② WHITE + CERULEAN BLUE

③ WHITE + CADMIUM YELLOW MEDIUM

④ WHITE + ALIZARIN CRIMSON

ADD WHITE and #3

#1 + RS

WT + #2 + •#3

#3

#1 + •#2

DARK BACK WATER

WT+ #1 and #2

WT+ #1 and #2

BRUSH MIXES

•#4

WT #3

WT + LY + •#2

BACK WATER

#1 + WT + •RS

DARK + •#2

WT + •LY + •#2

WT + • #4

#2 CYm

#4 FOR WARMTH

#2 + WT

WT + #3

WT + •UB

DARK #1 + RS

BRUSH MIX WT + •UB

+ •#4

WT + •#2

#3 + #2

SAND

WT + RS + •#4

ADD #2

WT + •#1 + •#2

#1 + AC + RS

ADD •AC + #1

#2 + RS

#4 + #2 + •RS

#3 + WT

ROCK and FLAT WATER

RS + AC

RS + AC + •#1

WHITE + •#3 TO LIGHTEN

#2 + RS

#1 + RS

Intentional and Accidental Color Mixes...

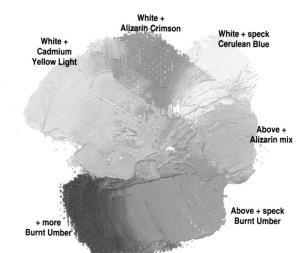

White + Cadmium Yellow Light

White + Alizarin Crimson

White + speck Cerulean Blue

Above + Alizarin mix

Above + speck Burnt Umber

+ more Burnt Umber

Using Blues, Pinks, and Purples

This exercise demonstrates the simple color wheel theory of mixing color complements across the wheel to make soft greys. The greys used in this painting are colorful even though they are soft in nature. They are lightened with white for the desired values. Adding white to alizarin crimson makes a pink; adding white to permanent blue creates a light blue; and adding white to cadmium yellow light produces a tinted yellow. Yellow, red, and blue are the primary colors, and even though they have been "tinted" with white, the same rules of the color wheel apply. For example, if the pink is mixed with the light blue, a tint of purple is created. If the mix is more pink, it is "orchid"; if it is more blue, it is "violet." Any tint of purple, whether pinkish or bluish, is known as "lavender." Most of the colors here were mixed with the brush from the "intentional" mixes (those made with a knife) shown at the top right. Mixing them in different proportions allows us to see the overall color mood of the painting in the "smearings."

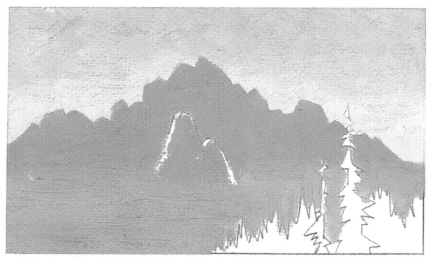

The sky and haze is white + cerulean blue + a speck of pink on the right. Add a speck of burnt umber to this mix for the mountain.

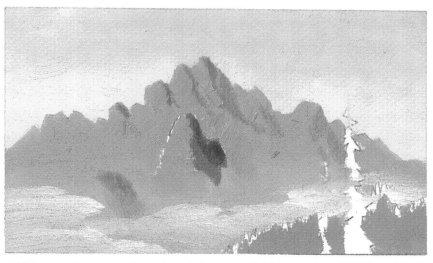

White + alizarin makes the pink glow. Add more burnt umber for shadows. Use the mountain color + a speck of cerulean blue for distant trees. White + alizarin crimson is used for the clouds.

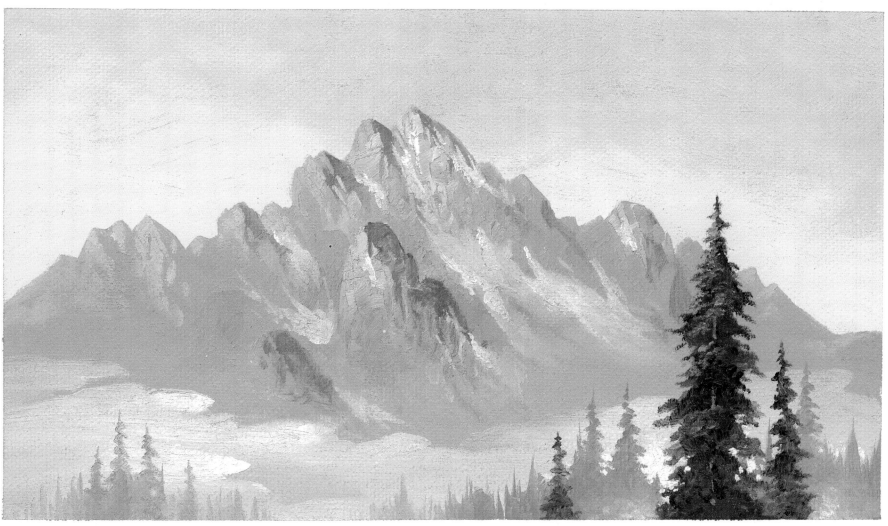

Add white and yellow mix to the pink for the soft peach glow. Permanent blue + cadmium yellow light + a speck of burnt umber is used for the dark trees. Cadmium yellow light + a speck of cerulean blue is used for the highlight greens. White and permanent blue is used for the shadow snow, while white added to the peach makes the sunlit snow. Keep the mixtures delicate—not harsh and raw. All of the "accidental" mixes are made with the brush as you paint.

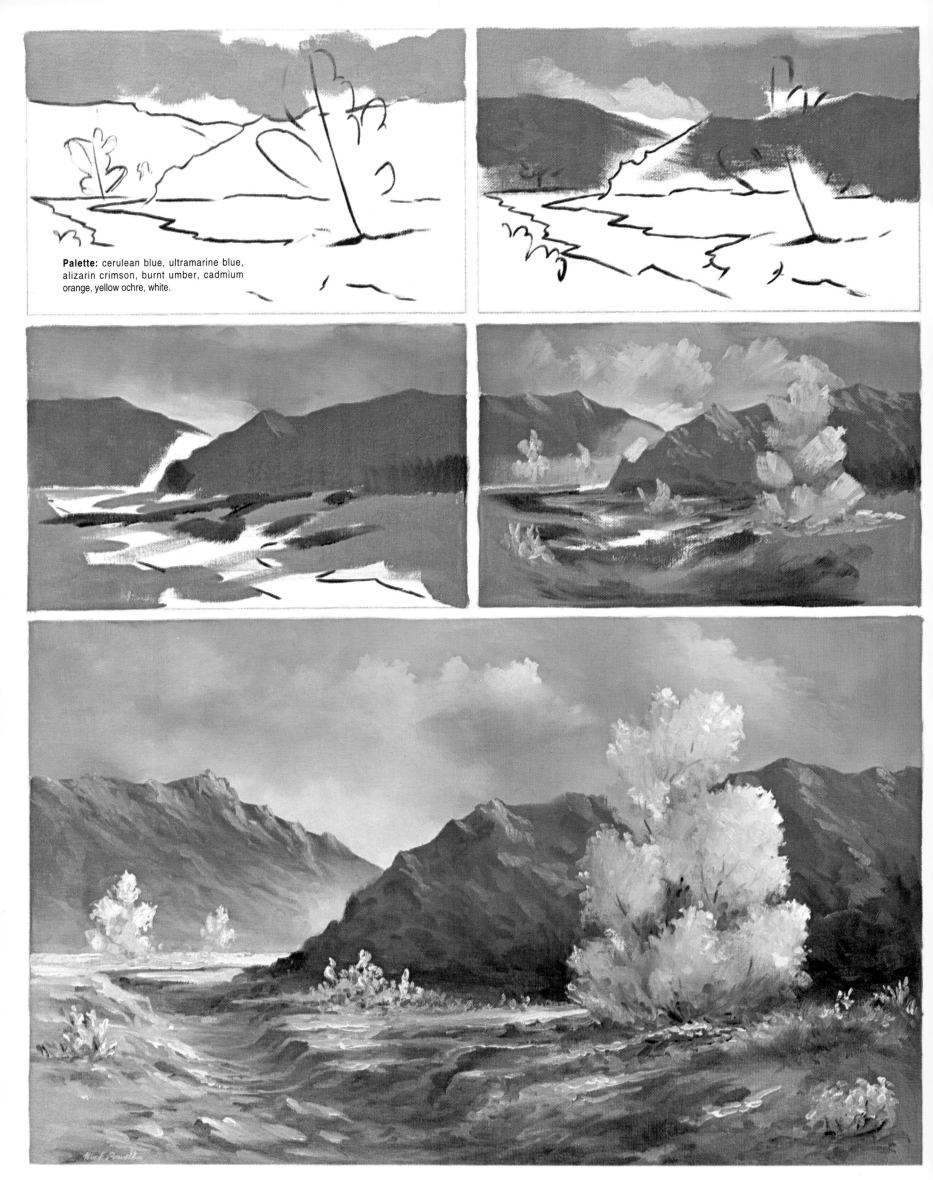

Palette: cerulean blue, ultramarine blue, alizarin crimson, burnt umber, cadmium orange, yellow ochre, white.

A mixture of cerulean blue and ultramarine blue makes a "fake" cobalt blue. When mixed with white, this blue is a delicate color for use in shadows. The dark front mountain is a mix of that blue + specks of alizarin crimson and burnt umber. Watch the values closely to prevent any one area from becoming dominant.

Morning...

A Study in Darks and Lights, Yellows and Purples,
Blues and Peaches, and Reds and Greens

The red-purple sky is a perfect complement to the yellow horizon and sunlit grasses. The greens are complemented by pink, and the burnt sienna trees in the middle ground are a perfect break between the two. The intentional knife mixes at the right are the main colors. If mixed correctly in the beginning, they can be intermixed during the painting process to create a wide variety of "accidentals." (These colors are actually "planned" accidents because the intentional mixtures were intended for this purpose.)

The most important part of color planning is the preparation and mixing in the beginning. It may take some time, but it is well worth the effort.

Use the pink and blue mixes above for the upper sky. Add white to the pink for the streaks, and then add the yellow mix in the horizon. Burnt sienna is used for the trees.

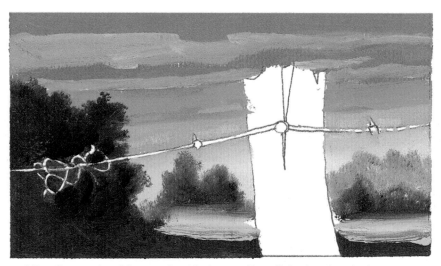

Mix ultramarine blue and cadmium yellow light for the dark greens, and lemon yellow and cerulean blue for the brighter greens. Paint the haze with the yellow horizon mix.

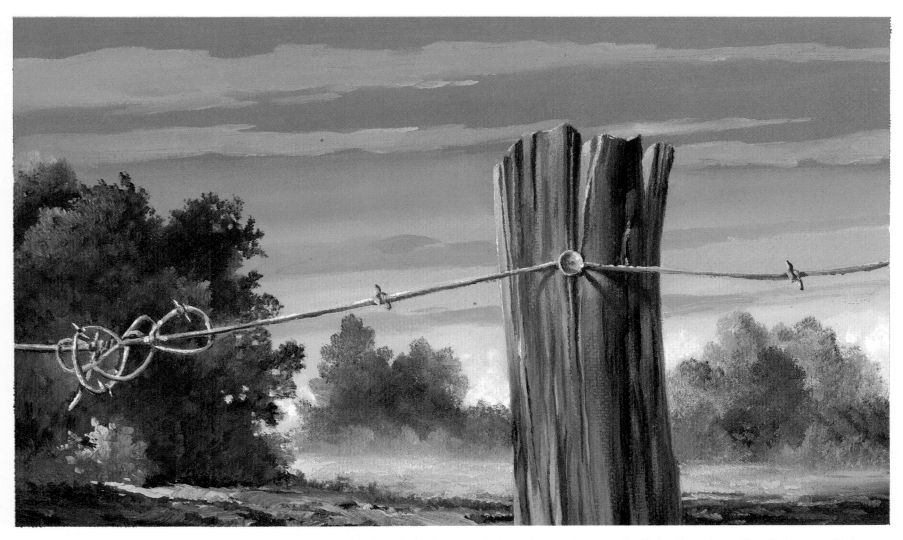

Add pure lemon yellow to the dark green for tree highlights. Paint in some foliage using the sky pink. The post is sky pink + light blue mix and burnt umber. Place a hint of yellow ochre and burnt sienna here and there to create warmth. Paint the wire with a light grey. Using a fine pointed brush, highlight with white and a speck of lemon yellow.

13

Dramatics of Color...

Light versus Dark

The purpose of this book is not only to help with your understanding of color, but also to introduce the great variety of color mixtures available by using just a few basic colors and the color wheel.

To accomplish a successful painting you need two things—a good drawing and proper color usage. Both will come with practice. Your pigments will provide an infinite variety of mixtures, and, by using them correctly, you can create depth, feeling, mood, and texture. To keep your colors fresh, keep in mind the light; respect white as a combination of all colors and black as the absence of light.

Notice that the first step here is drawing and blocking in with washes of basic colors. The only time I use turpentine or thinner to thin my paints is for these types of washes. During the painting process, if necessary, I thin the paint with linseed oil or a proper painting medium (see my book #AL17, *Oil Painting Materials and Their Uses*, pages 42-46, "Oils and Mediums"). If thinner is used exclusively, it can weaken the paint and destroy the color. Also, it can create dull spots on the final piece.

Palette: burnt umber, burnt sienna, alizarin crimson, cadmium orange, cerulean blue, prussian blue, ivory black, white.

After drawing, washes of the basic colors are blocked in (turpentine is used to dilute oil paints). Once the color is set, the excess is wiped away with a soft cloth.

Alizarin and a touch of cerulean makes a nice orchid color for the soft sky (a speck of ivory black is used to deepen the value when necessary). The clouds are white plus a speck of cadmium orange. The ground is burnt umber plus alizarin and cerulean.

The mountains are burnt sienna with a speck of cadmium orange in the base; the highlights are white plus a speck of orange, and the shadows are created by blending in some ground mixture. The grasses are orange and white plus a touch of cerulean.

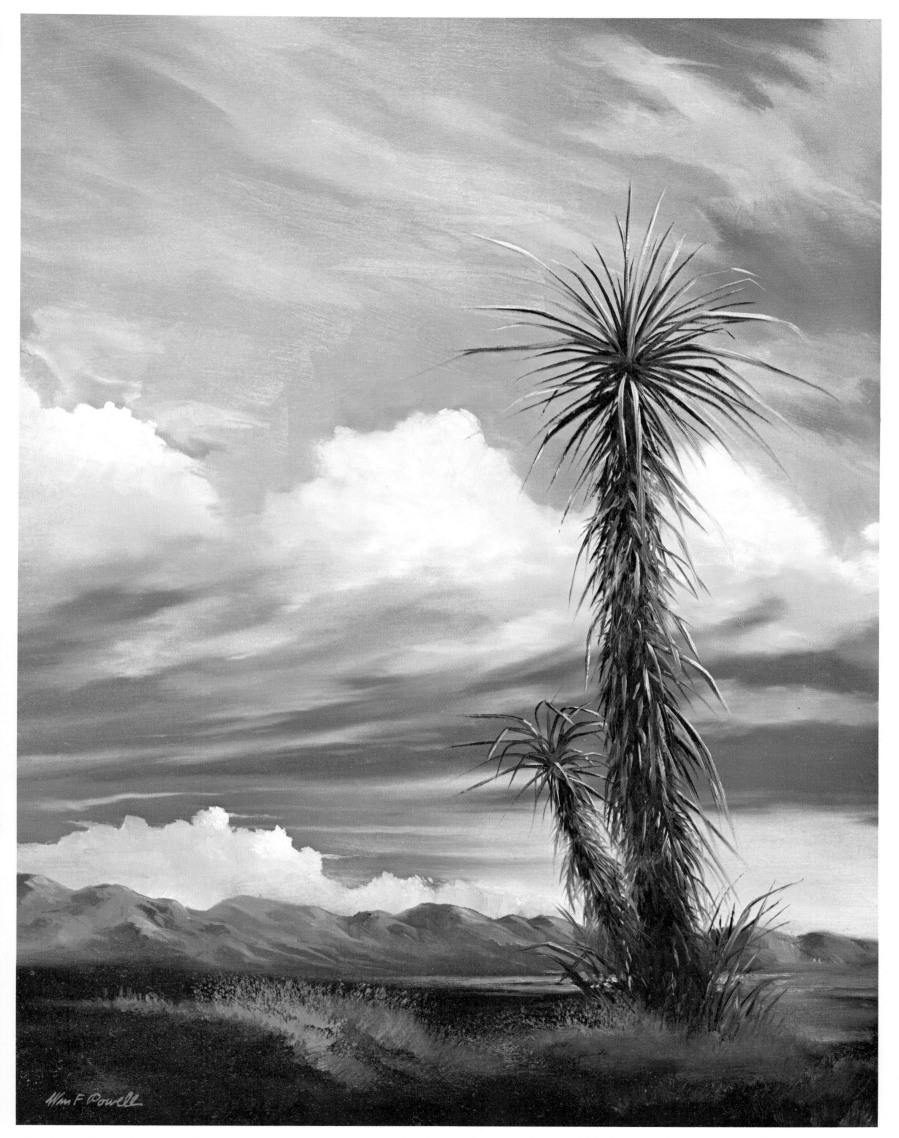

The foliage in the foreground not only acts as an interest point, but it also adds warmth to the painting. Start with the darker colors and then build up the lights. Burnt sienna plus cerulean blue creates a soft greenish grey. This is a good color to build into either lighter greens or warmer shadows.

Monochromatic Color...

Monochromatic Feeling

A painting with a monochromatic color scheme is made with just one color in various intensities using tints (the addition of white), tones (the addition of grey), shades (the addition of black). White lightens and pales the color, while black darkens and dulls it. I like to use color in such a way as to create what I call a "monochromatic feeling" or "family of colors." The colors create an overall feeling of a monochromatic painting, yet they have just a bit more sparkle. This is because one color is selected to be the dominant color, and all the other colors are used to accent, grey, or otherwise subtly affect it. In the painting below, I selected a very simple palette of cerulean blue, permanent blue, alizarin crimson, burnt umber and titanium white. Choose a color combination of your own, and try creating a painting with a "monochromatic feeling."

White + Cerulean Blue

White + Permanent Blue

White + Alizarin Crimson

2 parts Burnt Umber + 1 part Alizarin Crimson

Use a mix of white and alizarin in different values for the overall dominant color. Add a speck of permanent blue for the subtle purple in the sky and water. Use more white for light.

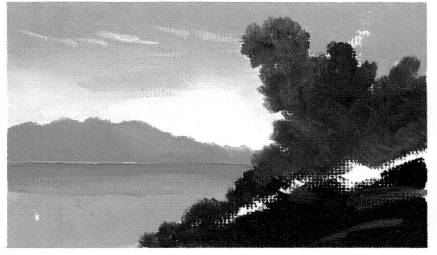

Continue with white, alizarin, and blue. Add the darks in the foreground with a mix of burnt umber and alizarin crimson. Use the sky colors for lightening and softening.

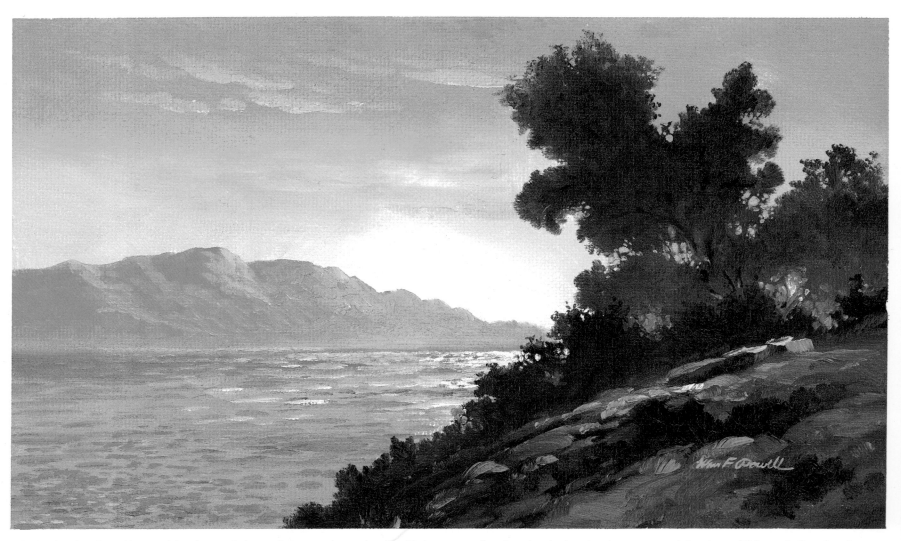

Paint in details with combinations of the colors used previously. Paint the leaves using the corner of a small bright-style sable brush. Add the highlights in the foreground with white, blue, and a slightly stronger mix of alizarin crimson and white. After the painting has dried a bit, go back and paint the holes in the tree and bushes. This painting is shown actual size. Try some small paintings of your own; they are great fun and make beautiful compositions.

Selecting the Proper Colors...

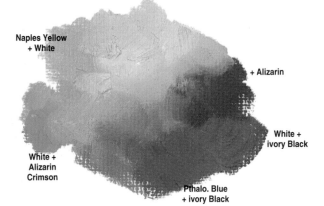

Naples Yellow + White
+ Alizarin
White + ivory Black
White + Alizarin Crimson
Pthalo. Blue + ivory Black

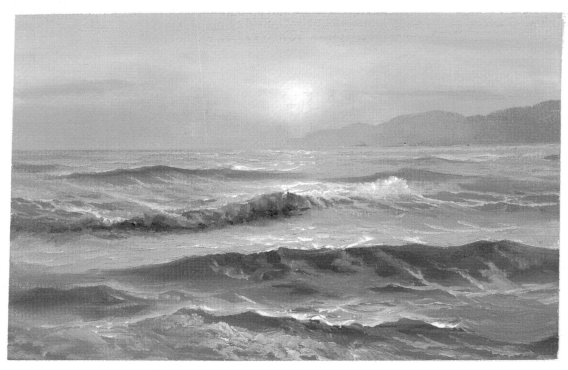

Yellows

The overall dominant color in this painting is yellow. Thus, yellow is known as the "key" color, and a bit of yellow is used in all mixtures. When planning a color scheme and mood, choose a "key" color to hold the painting together. This creates an overall unity in the painting, and no color stands out drastically from the others.

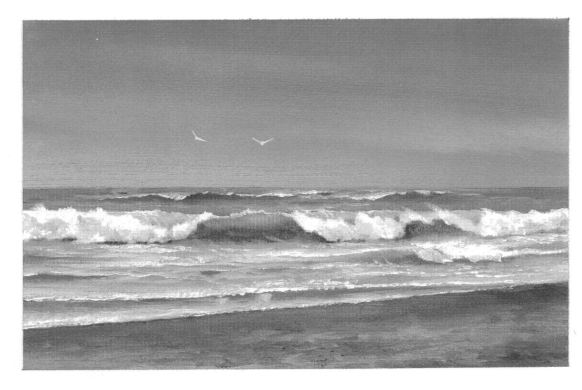

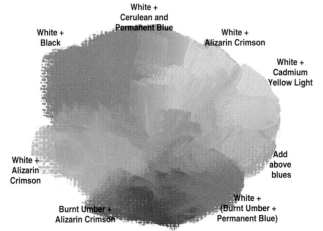

White + Cerulean and Permanent Blue
White + Black
White + Alizarin Crimson
White + Cadmium Yellow Light
White + Alizarin Crimson
Add above blues
Burnt Umber + Alizarin Crimson
White + (Burnt Umber + Permanent Blue)

Blues and Greens

Blue dominates this daylight scene at the beach. Blue is the "key" color, as it is added to all mixtures, even the whites and greys of the foam. Notice the mixtures and the use of black. This bluish black was mixed from other colors (as discussed on page 9) to keep it within the color plan. Refer to the paint smearings and notice how the greens are mixed.

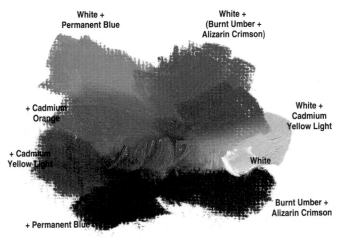

White + Permanent Blue
White + (Burnt Umber + Alizarin Crimson)
+ Cadmium Orange
+ Cadmium Yellow Light
White
White + Cadmium Yellow Light
+ Permanent Blue
Burnt Umber + Alizarin Crimson

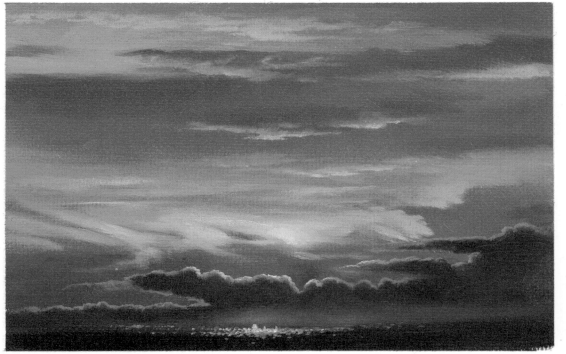

Reds and Oranges

Alizarin crimson is the "key" or dominant color in this setting sun scene. Permanent blue and white are added to make some of the purples. The dark clouds are a combination of burnt umber, alizarin crimson, and permanent blue (a speck of white is added for the haze). Blue and umber are added for the dark land. All three of these paintings are oil sketches, shown actual size.

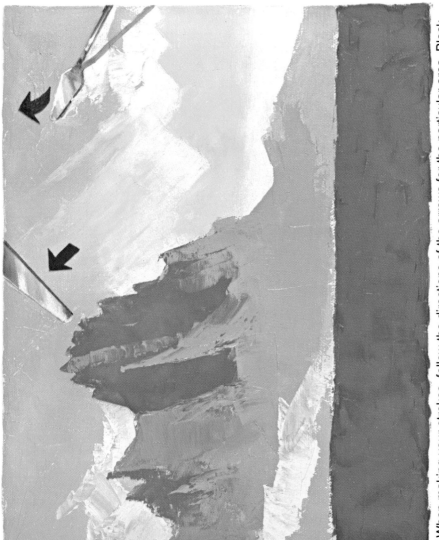

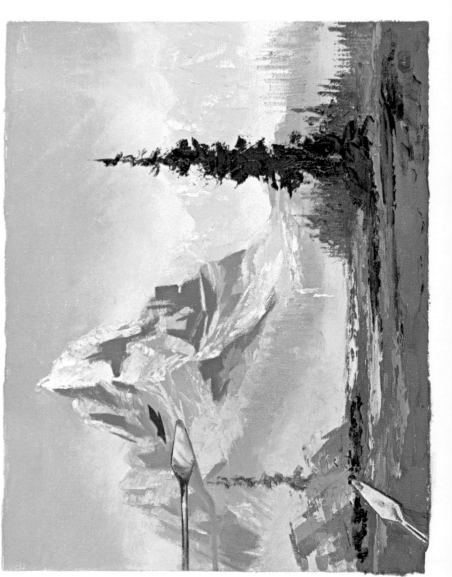

When making your strokes, follow the directions of the arrows for the particular area. Block in the masses first, and then paint the detail. Try to keep your colors cool and fresh.

Painting with a Knife...

Palette: burnt umber, alizarin crimson, cadmium orange, yellow ochre, cadmium yellow light, ultramarine blue, cerulean blue, white.

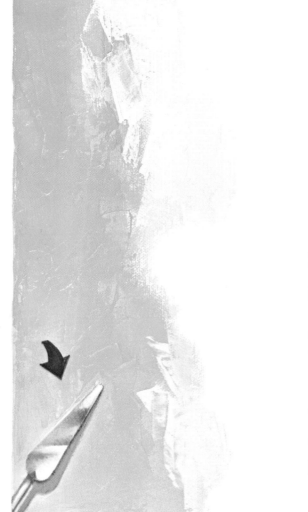

Start the sky using white and ultramarine blue. For variation, cerulean is a more greenish blue compared to the indigo feeling of ultramarine.

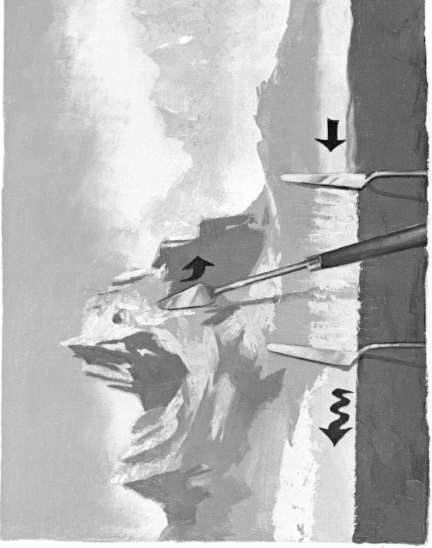

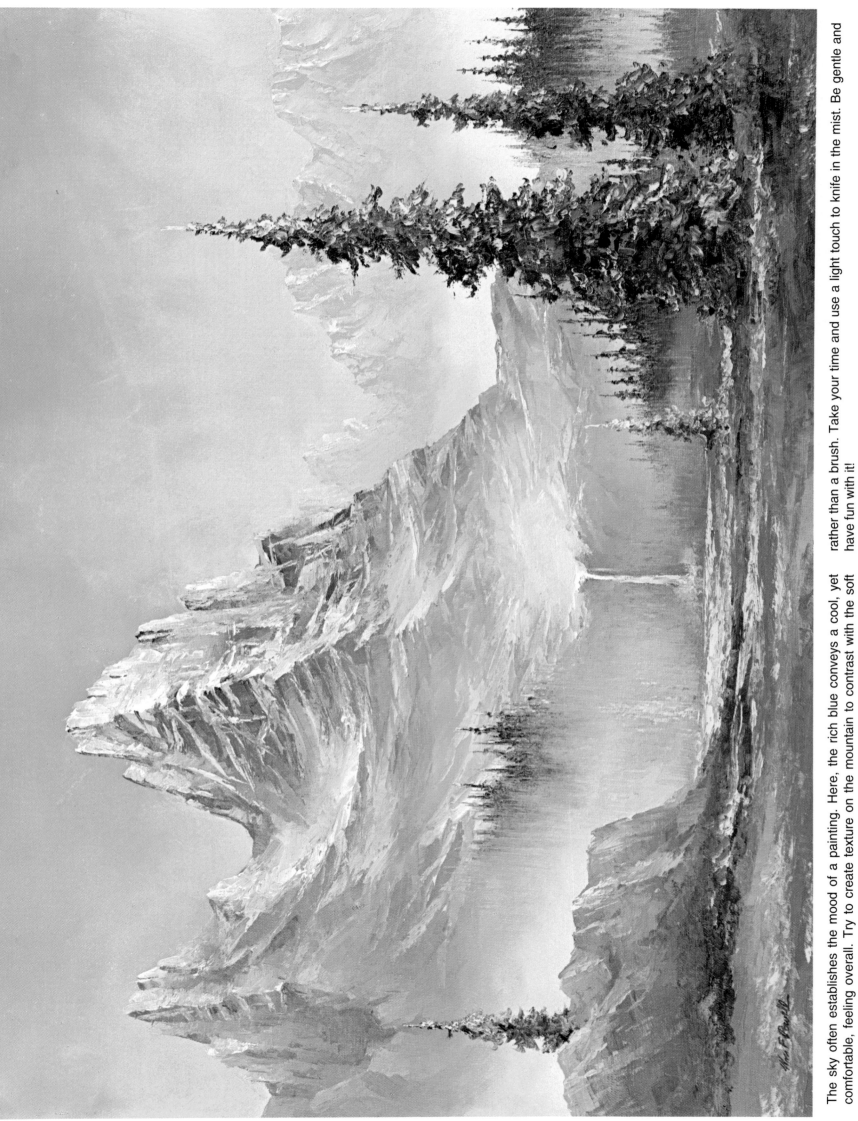

The sky often establishes the mood of a painting. Here, the rich blue conveys a cool, yet comfortable, feeling overall. Try to create texture on the mountain to contrast with the soft mist at the base. Some people cannot believe that such soft mists were painted with a knife rather than a brush. Take your time and use a light touch to knife in the mist. Be gentle and have fun with it!

The addition of blue to your mountain colors will make them appear to be in the distance. Deepen your colors slightly when working your way forward.

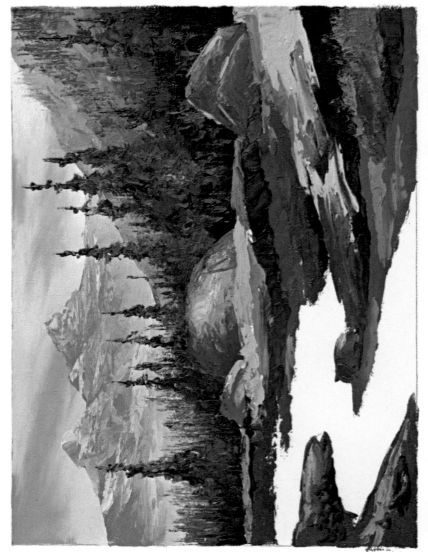

Mixes of yellow ochre + ultramarine blue and cadmium yellow light + ultramarine and prussian blues are used for the greens. Add a speck of umber or Alizarin to bronze them.

Palette: burnt umber, burnt sienna, raw sienna, alizarin crimson, cadmium red light, yellow ochre, cadmium yellow light, lemon yellow, ultramarine blue, prussian blue, manganese blue, white.

Manganese blue is introduced in this painting; it is the coldest blue (it is also a fast-drying pigment). This blue makes some very delicate shades when mixed with white and alizarin crimson. Use some of it in your sky.

Notice the blue tint of the hill on the right. This keeps it well back from the trees. Use fresh, deep colors in the trees and foreground.

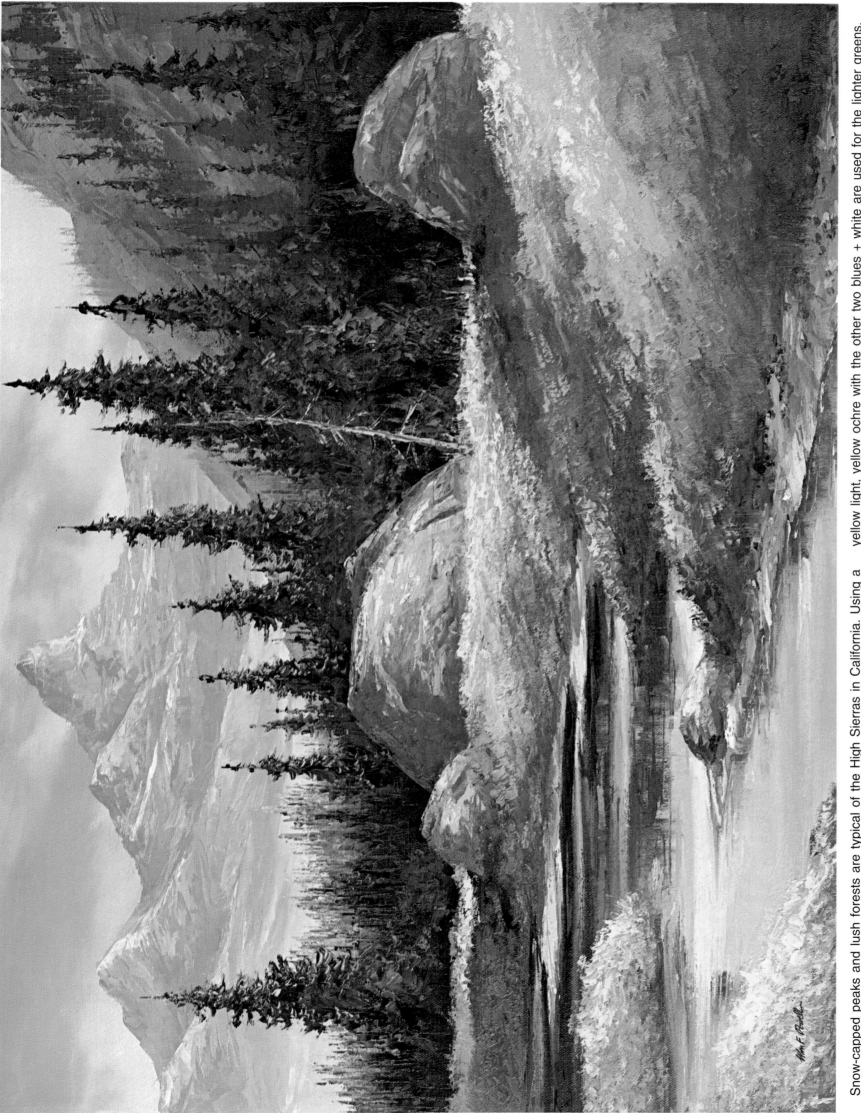

Snow-capped peaks and lush forests are typical of the High Sierras in California. Using a knife to paint them adds to their rugged personality. The tip of the knife and a mix of burnt umber and prussian blue are used for the dark green branches and shapes. Cadmium yellow light, yellow ochre with the other two blues + white are used for the lighter greens. The colors are muted with burnt umber.

21

Rocks... Small Color Sketches Done on Location are Valuable References Back in the Studio

White +
Cad. Yellow Lt.

White +
Cad. Red Lt.

Burnt
Sienna

Burnt Umber +
speck Ultra. Blue

Burnt Umber +
Prussian Blue

Cad. Yellow Lt.
+ Cerulean Blue

Lemon Yellow +
Cerulean Blue

Burnt Umber

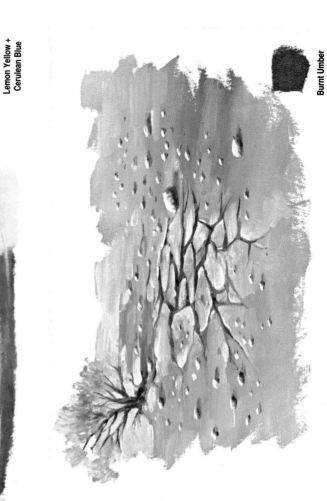

Cad. Yellow Lt.

White +
Raw Umber

Burnt Umber

Yellow Ochre +
Cad. Orange + White

Burnt Umber +
Cad. Orange + White

White +
Yellow Ochre

White+
Yellow Ochre

Raw Sienna

Burnt Umber

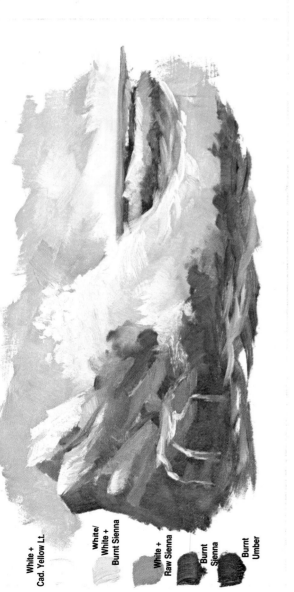

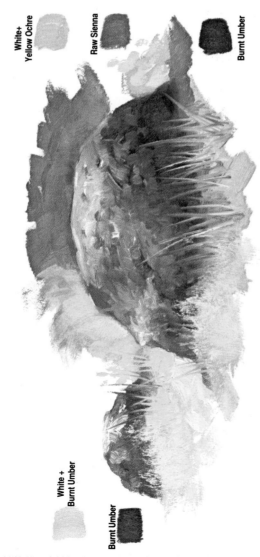

White +
Cad. Yellow Lt.

White/
White +
Burnt Sienna

White +
Raw Sienna

Burnt
Sienna

Burnt
Umber

White +
Burnt Umber

Burnt Umber

Cad. Orange

Burnt Umber

Cad. Yellow Lt.

Cad. Red Lt.

22

This painting of an Arizona plateau is accomplished with a loose brush technique. The green in the sky moves toward softer, deeper colors on the left, which adds to the afternoon mood. The sun at this time of day creates long shadows. Notice the soft purple in the distant valley. Add a bit of white to your greens to soften them. Mix burnt umber and alizarin crimson for the underpaint in the dark foreground. Add burnt sienna for warmth.

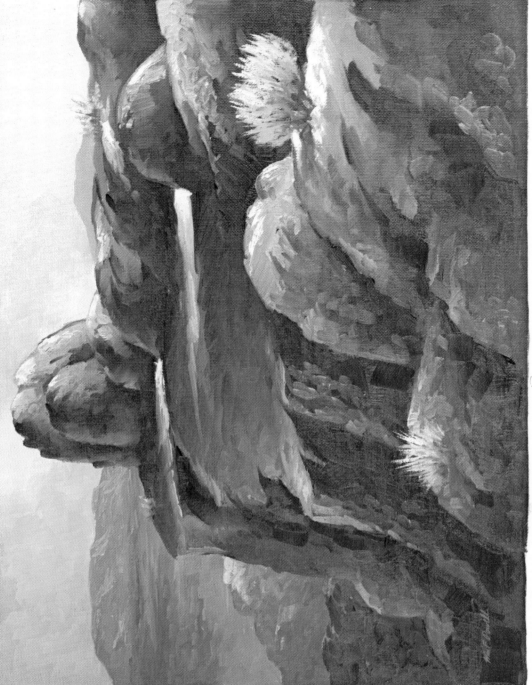

Palette: burnt umber, burnt sienna, yellow ochre, alizarin crimson, cerulean blue, ultramarine blue, cadmium orange, cadmium yellow light, white.

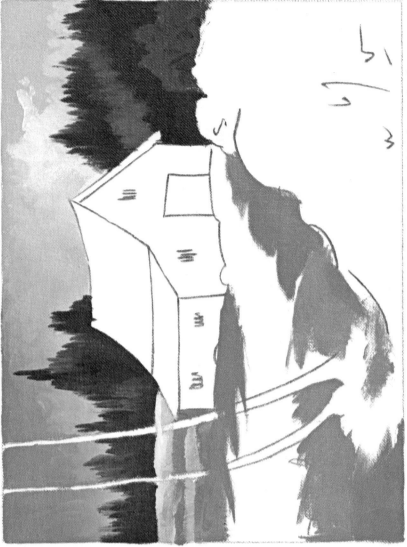

The mood of the sky dictates the mood of all the other colors, so keep the greys fresh. Block in the masses before adding details.

Palette: burnt umber, burnt sienna, yellow ochre, alizarin crimson, prussian blue, cerulean blue, ultramarine blue, cadmium orange, cadmium yellow light, white.

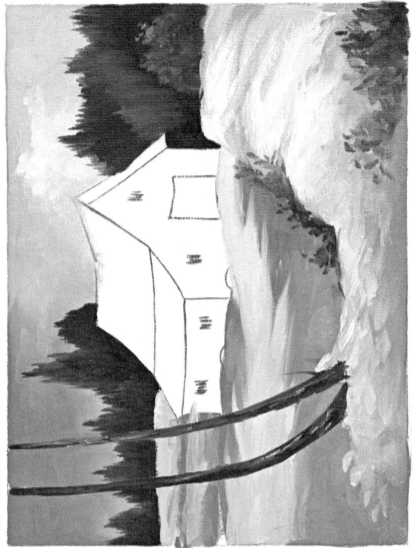

Use burnt sienna and burnt umber (greyed with cerulean blue) to mix the warm background trees. Try to keep the textures soft and suggestive using mass form to make the statement.

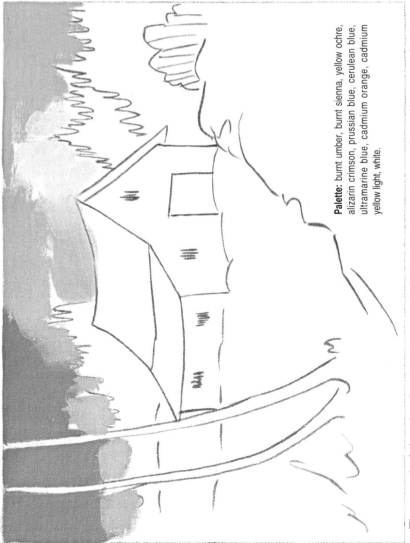

Alizarin crimson and the two blues are the key to the purple colors. Use more alizarin for orchid and more blues for violet. Splash them in loosely.

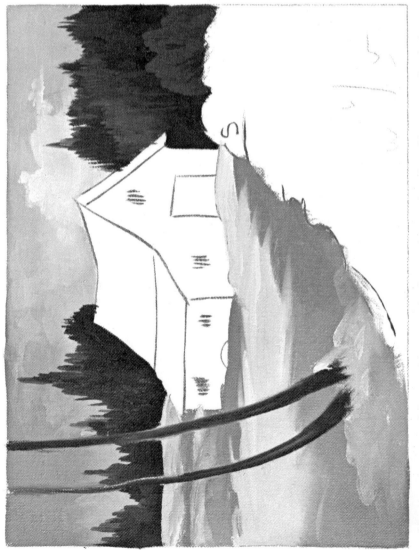

The shape of the land beneath the snow dictates the form of the snow. However, the snow fills in and softens it. Keep your brush strokes smooth—not angular.

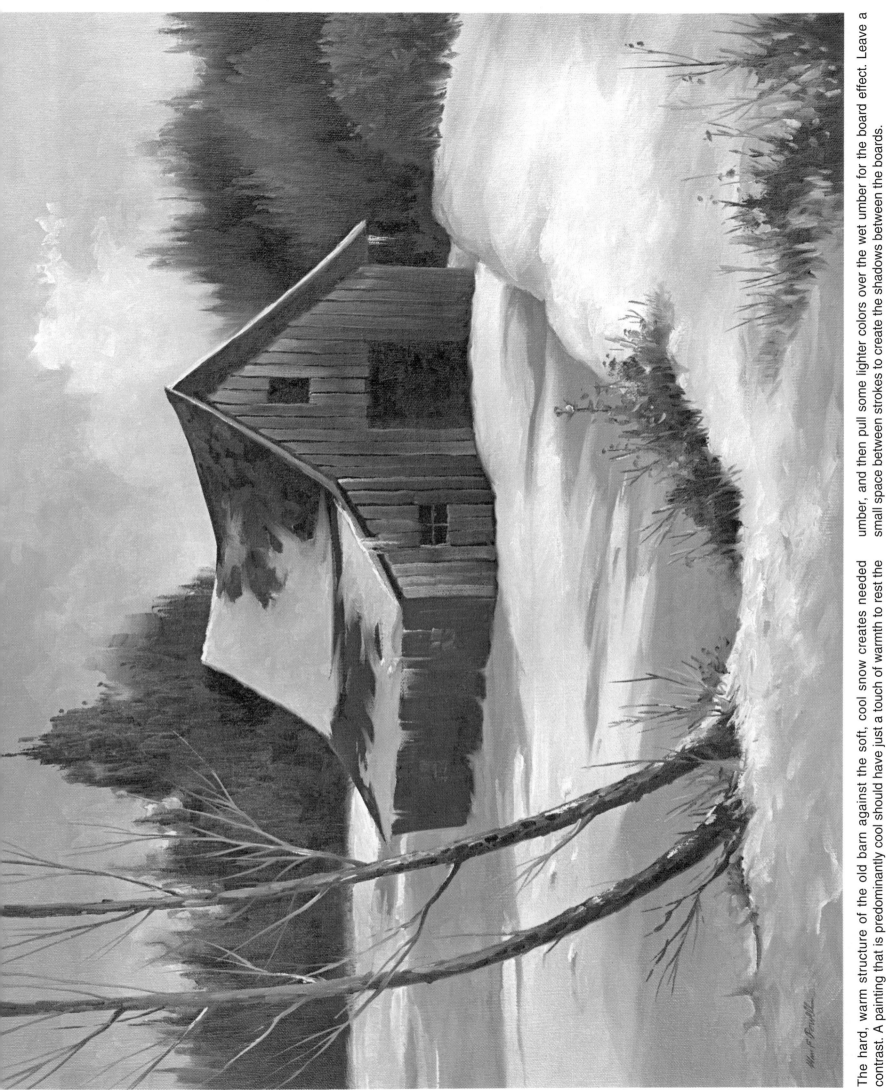

The hard, warm structure of the old barn against the soft, cool snow creates needed contrast. A painting that is predominantly cool should have just a touch of warmth to rest the eye. The reverse is true for a predominantly warm painting. Paint the old barn solid burnt umber, and then pull some lighter colors over the wet umber for the board effect. Leave a small space between strokes to create the shadows between the boards.

Sketch in the windmill structure first. The sky will cover it a bit, but at least you will have mentally placed it properly.

Palette: burnt umber, burnt sienna, alizarin crimson, cadmium red light, cadmium orange, cadmium yellow light, ultramarine blue, prussian blue, white.

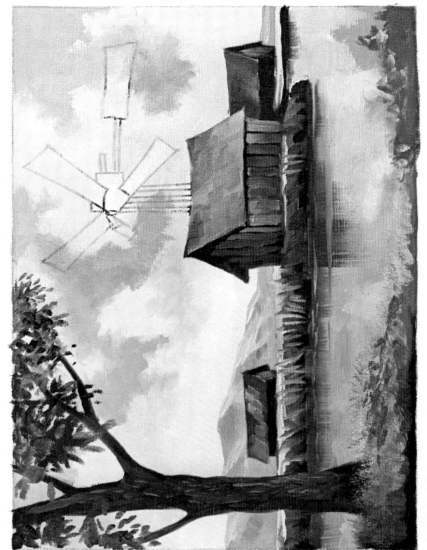

Bright blues and peachy clouds work well together. A mix of white and a speck of cadmium orange makes a nice peach. Highlight with white.

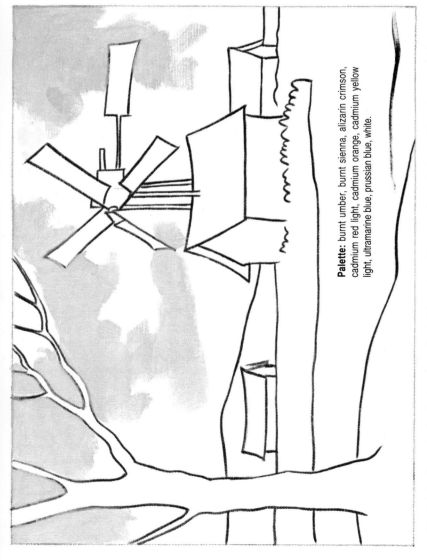

The windmill structure is painted using the same method as the barn on page 25. Paint in the the base of the grasses.

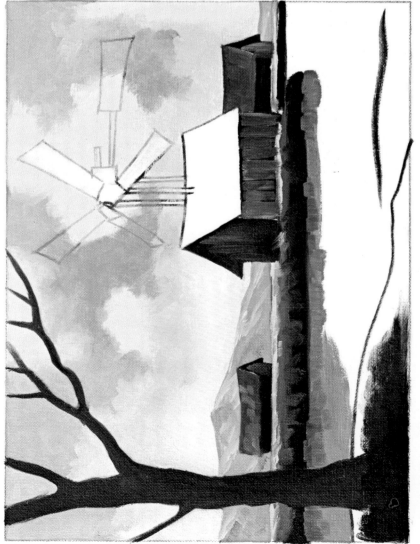

Now add the reflections. Remember that the vertical strokes show the reflection and the horizontal strokes over them create the surface effects.

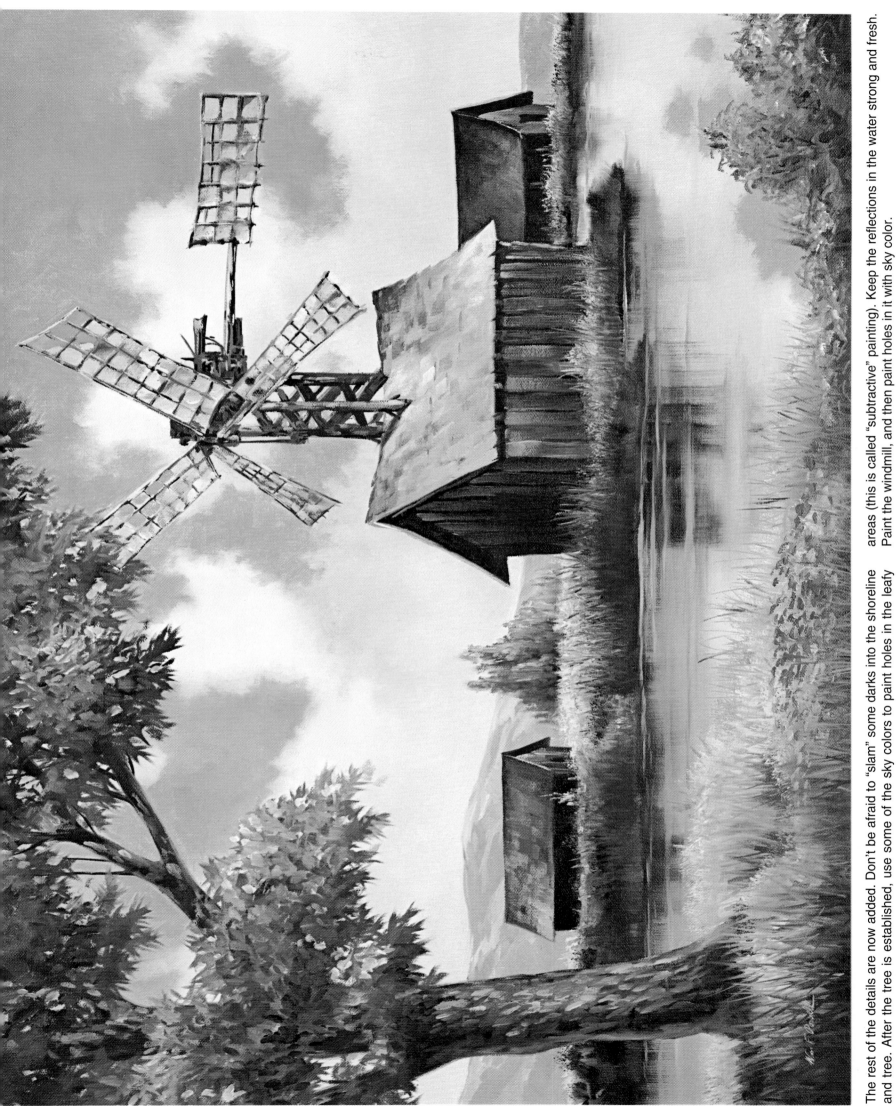

The rest of the details are now added. Don't be afraid to "slam" some darks into the shoreline and tree. After the tree is established, use some of the sky colors to paint holes in the leafy areas (this is called "subtractive" painting). Keep the reflections in the water strong and fresh. Paint the windmill, and then paint holes in it with sky color.

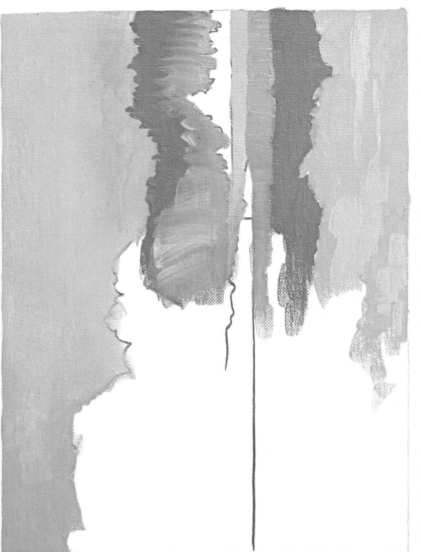

Palette: cerulean blue, prussian blue, burnt umber, cadmium orange, cadmium yellow light, white.

Sketch in the subject for composition and placement. Notice the vertical line. This indicates the largest tree and its reflection.

When blocking in the masses, remember that the reflections are as deep as the objects are tall.

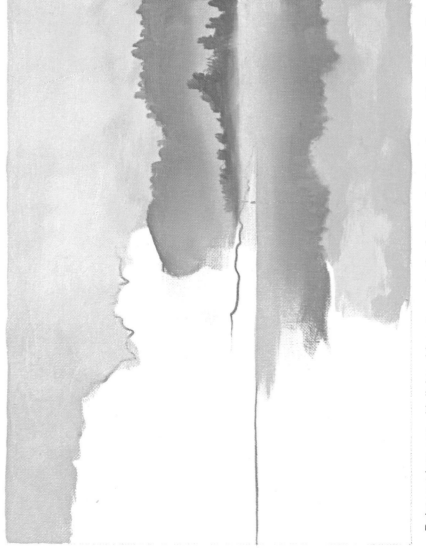

Paint wet-into-wet with lighter blues to create the feeling of mist and ground fog. Keep all colors fresh and remember the values.

Prussian blue plus burnt umber makes a rich blue-black. Burnt umber is actually a very deep tone of orange-red, so it is extremely versatile.

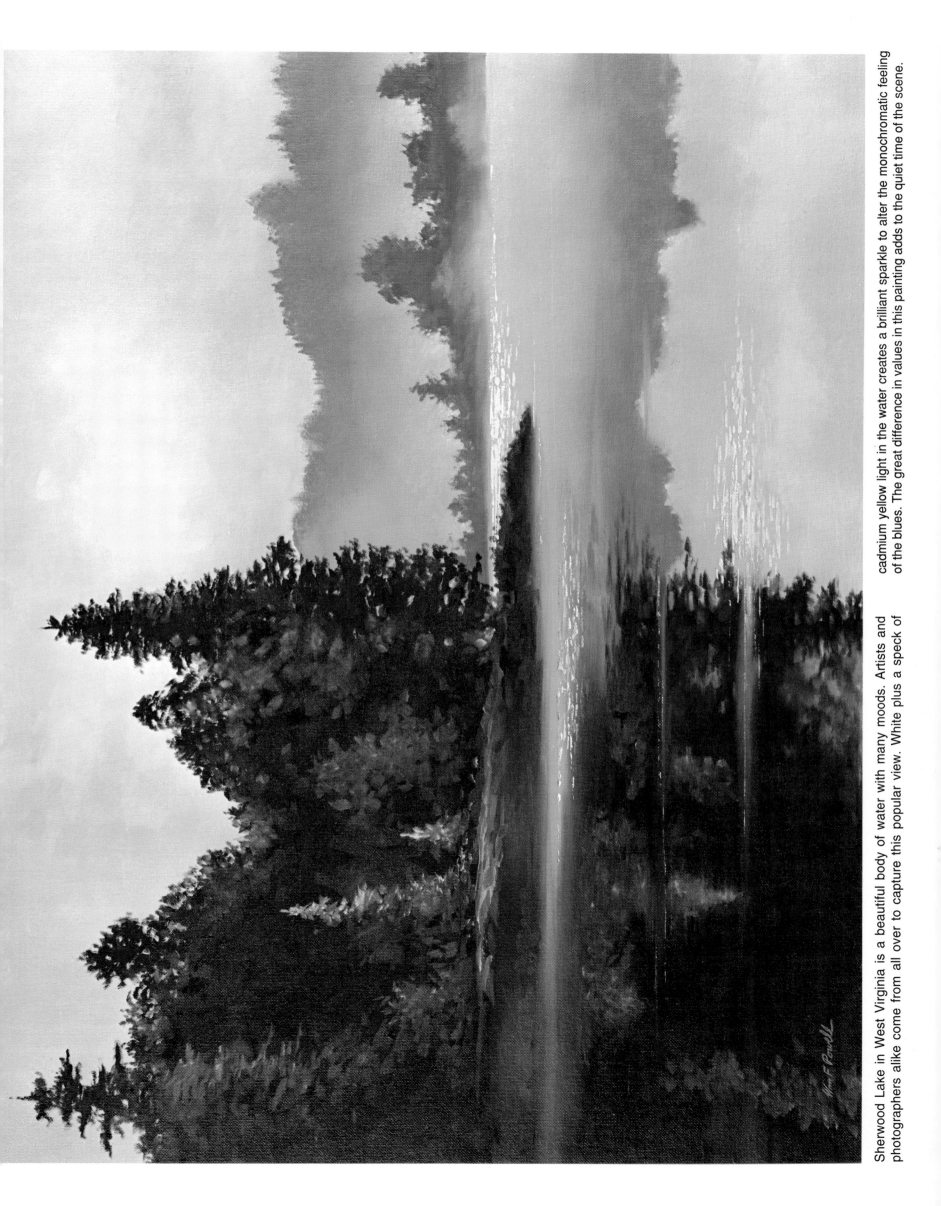

Sherwood Lake in West Virginia is a beautiful body of water with many moods. Artists and photographers alike come from all over to capture this popular view. White plus a speck of cadmium yellow light in the water creates a brilliant sparkle to alter the monochromatic feeling of the blues. The great difference in values in this painting adds to the quiet time of the scene.

Anatomy of a Waterdrop...Color Within a Colorless Object

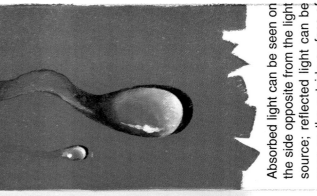

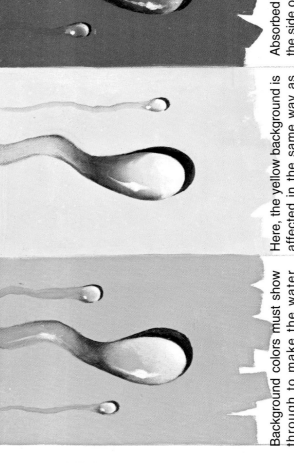

Light Direction

Water is like glass; even though it is transparent, it absorbs light and dark.

Darkness absorbed in water

Reflected highlight

Absorbed darkness

Absorbed light glow

Cast shadow

Even though water is transparent, it still blocks light and casts a shadow. The depth of the shadow depends upon the thickness and shape of the water.

Fallen Drops

Spilled Pool

Background colors must show through to make the water appear transparent. The thickness of the drop at the bottom and the absorption of light changes the value of the background green.

Here, the yellow background is affected in the same way as the green background. Notice that in the "neck" of the drops, the absorption of dark (lack of light) changes the background colors to a darker value.

Absorbed light can be seen on the side opposite from the light source; reflected light can be seen on the outside surface of the drops on the side the light source reaches.

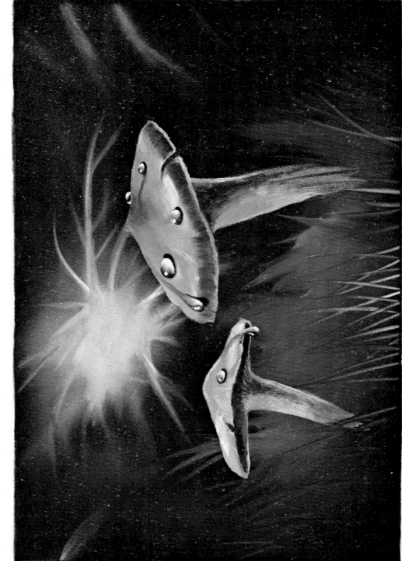

Although the palette for these two paintings is the same, the color moods are totally different because of different mixtures.

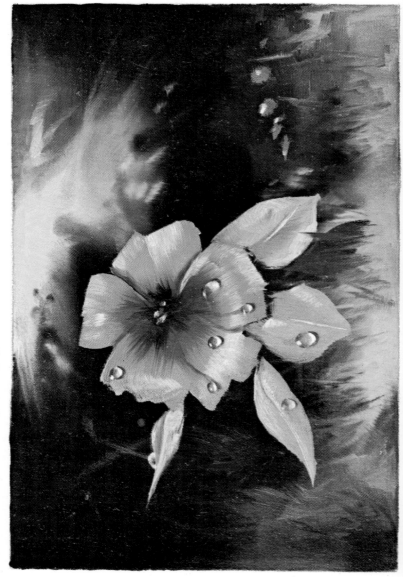

The palette for both of these little woodland scenes is: burnt umber, alizarin crimson, prussian blue, cadmium yellow light, and white.

Water, ice, glass, and some plastics are good subjects to study for learning about light and dark absorption. A clear liquid becomes a sort of lens when poured into a clear glass. Experiment! Shine a flashlight through an empty drinking glass and observe how the lights and darks are placed. Move the light around and watch how they travel around the glass. Notice, also, the surface on which the glass is sitting. Then fill the glass with a clear liquid and repeat the light study. Quite a change takes place with the lights and darks. The liquid becomes a solid form in the shape of the glass. This creates a lens that will both absorb light and dark and project light. Study the water drops on a window or freshly washed fruit and vegetables. Look at the condensation on the outside of a cold soda bottle. Practice painting each of these forms.

The light comes from the left, so the left side of the drop remains sharp. The tip of the brush is used to blend the inside dark areas. The highlight area is white.

Now the details are painted. The shadow is added around the lower right side, and a dot of pure white is placed in the softened area of reflected light. This establishes the outer surface of the drop.

A round pointed sable brush and burnt umber is used to draw the absorbed dark side of the drops. This establishes the shape of the left side of the drops.

The tip of the brush is used to drag the color up, creating the drop's pathway. White is used for the absorbed light in the lower right side of the drop.

Using oranges as a base, follow these steps to paint water drops on them. Be careful, however, because too many drops tend to make the painting appear too busy.

31